To: Michael
Une bonne vie
Verlie Sonnier
11/16/16

CH_____
in Cajun Country

Noël dans Pays Cadien

FLOYD SONNIER

FIRST PRINTING - ONE THOUSAND

NUMBER _____ 120

CHRISTMAS
in Cajun Country

Noël dans Pays Cadien

CHRISTMAS
in Cajun Country

Noël dans Pays Cadien

FLOYD SONNIER

Acadian House
PUBLISHING
Lafayette, Louisiana

ON THE COVER: *"Christmas Magic on the Cajun Prairie,"* © Floyd Sonnier

Library of Congress Cataloging-in-Publication Data

Sonnier, Floyd, 1933-2002, artist. | Angers, Trent, editor.
Christmas in Cajun country / by Floyd Sonnier ; edited by
 Trent Angers.
Lafayette, LA : Acadian House Publishing, 2016. |
 Includes index.
LCCN 2016045109 | ISBN 0925417866 (hardcover)
LCSH: Sonnier, Floyd, 1933-2002--Themes, motives. |
 Christmas in art. | Cajuns in art.
LCC NC139.S595 A4 2016 | DDC 741.973--dc23
 LC record available at https://lccn.loc.gov/2016045109

◆ Published by Acadian House Publishing, Lafayette,
 Louisiana (Edited by Trent Angers; editorial assistance
 by Darlene Smith; pre-press production by Charlotte Huggins)

◆ Translation to French by Michael Vincent,
 Baton Rouge, Louisiana

◆ Cover design and production by Glenn Noya,
 New Orleans, Louisiana

◆ Printed by Walsworth Printing, Marceline, Missouri

In memoriam

Floyd Sonnier
(1933-2002),
"The Artist of the Cajuns,"
who worked tirelessly
to capture the charm
and the holiness
of Christmas

À la mémoire de

Floyd Sonnier
(1933-2002),
"L'artiste des Cadiens,"
qui a travaillé sans relâche
à capturer le charme
et la sainteté
de Noël

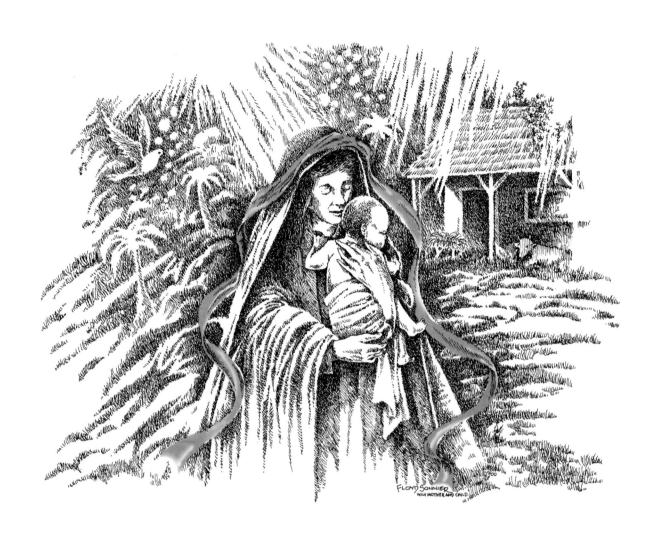

Holy Mother and Child

La Sainte Mère et l'Enfant

A multitude
of Christmas images

Floyd Sonnier (1933-2002) is most widely known for his pen-and-ink drawings that capture various aspects of life in oldtime south Louisiana.

He grew up on a sharecropper's farm in the 1930s and '40s, and much of his art shows us what this country boy routinely experienced: playing marbles under the oaks, crawfishing, picking cotton, playing baseball, riding in a horse-drawn buggy. Some of his other art depicts his family members, farm animals, old buildings and various customs of the day.

His original art, as well as prints of many of these pieces, can be found in homes and offices in Louisiana, Canada, France, Belgium and elsewhere.

But none of his work has found expression in so many forms as his Christmas drawings. Many of these images have been reproduced on Christmas cards, Christmas ornaments, calendars and posters and in various periodicals. These images make up the heart of this book. Here you'll find a broad array of Holiday Season drawings from a prolific artist with a reverent, sometimes whimsical, worldview: Madonna and Child, angel attending the Baby Jesus, manger scene with the three wise men, Santa Claus holding the Baby Jesus, the little drummer boy, Santa in a *pirogue*, Santa with a docile alligator, Santa on the accordion, and more.

Floyd began making and selling Christmas cards around 1980 and did so until his death in 2002. His widow, Verlie, continued the tradition.

Many of these same printed images were used to make Christmas ornaments that grace the Christmas trees and mantels of homes in south Louisiana. Stencils of the art were made, then fired onto white ceramic pieces of various shapes. These can be seen on pages 65-67.

Even today, so many years after his passing, Floyd's love of Christmas lives on in his art. This book is intended as a means of preserving and sharing Floyd's beautiful vision of his favorite time of the year.

– *Trent Angers, OFS*
Editor

Une multitude
d'images de Noël

Floyd Sonnier (1933-2002) est plus largement connu pour ses dessins à la plume et à l'encre qui capturent divers aspects de la vie dans le vieux temps du sud de la Louisiane.

Il a grandi sur la ferme d'un métayer dans les années 1930 et 40, et une grande partie de son art nous montre quoi ce garçon de la campagne a couramment connu: jouer aux billes sous les chênes, pêcher des écrevisses, cueillir du coton, jouer au baseball, monter dans un buggy tiré par des chevaux. D'autres œuvres d'art représentent les membres de sa famille, les animaux de la ferme, des bâtiments anciens et divers activités de la journée.

Son œuvre originale, ainsi que des reproductions de plusieurs de ces pièces, peuvent être trouvées dans les maisons et les bureaux de Louisiane, du Canada, de France, de Belgique et d'ailleurs.

Mais aucun de ses travaux n'a trouvé d'expression dans autant de formes que dans ses dessins de Noël. Beaucoup de ces images ont été reproduites sur des cartes de Noël, décorations de Noël, des calendriers, des affiches et dans divers périodiques. Ces images constituent le cœur de ce livre. Vous-autres trouverez ici un large éventail de dessins de la saison de Noël par un artiste prolifique avec une vision du monde respectueuse, parfois capricieuse : la Vierge et l'Enfant, l'ange avec l'Enfant Jésus, une scène de crèche avec les trois mages, le Père Noël tenant l'Enfant Jésus, le petit joueur de tambour, le Père Noël dans une pirogue, le Père Noël avec un cocodrie docile, le Père Noël à l'accordéon, et plus.

Floyd a commencé à fabriquer et à vendre des cartes de Noël autour de 1980 et l'a fait jusqu'à sa mort, en 2002. Sa veuve, Verlie, a poursuivi la tradition.

Beaucoup de ces mêmes images imprimées ont été utilisées pour faire des ornements de Noël qui décorent les arbres de Noël et les manteaux de maisons dans le sud de la Louisiane. Des pochoirs d'œuvres ont été faits, puis ont été cuits sur des pièces en céramique blanche de différentes formes. Elles peuvent être vues sur les pages 65-67.

Aujourd'hui encore, tant d'années après sa mort, l'amour de Floyd pour Noël vit dans son art. Ce livre est conçu comme un moyen de préserver et de partager la belle vision de Floyd pour son moment préféré de l'année.

The Little Drummer Boy

Come they told me
 Pa rum pum pum pum
A new born king to see
 Pa rum pum pum pum
Our finest gifts we bring
 Pa rum pum pum pum
To lay before the king
 Pa rum pum pum pum,
 Rum pum pum pum,
 Rum pum pum pum
So to honor him
 Pa rum pum pum pum
When we come
 Pum pum pum pum
 Pa rum pum pum
 Pum pum pum pum
 Pa rum pum pum
 Pum pum pum pum
 Pa rum pum pum

Pum pum pum pum pa rum
Little baby
 Pa rum pum pum pum
I am a poor boy, too
 Pa rum pum pum pum
I have no gift to bring
 Pa rum pum pum pum
That's fit to give our king
 Pa rum pum pum pum,
 Rum pum pum pum,
 Rum pum pum pum
Shall I play for you?
 Pa rum pum pum pum
 Pa rum pum pum
 Pum pum pum pum
Mary nodded
 Pa rum pum pum pum
The ox and lamb kept time
 Pa rum pum pum pum

I played my drum for him
 Pa rum pum pum pum
I played my best for him
 Pa rum pum pum pum,
 Rum pum pum pum,
 Rum pum pum pum
Then he smiled at me
 Pa rum pum pum pum
Me and my drum

Come they told me
 Pa rum pum pum pum
A new born king to see
 Pa rum pum pum pum
Me and my drum
Me and my drum
Me and my drum
Me and my drum
 Rum pum pum pum

"The Little Drummer Boy" is a popular Christmas song believed to have been written in 1941 by American composer Katherine Kennicott Davis. Others associated with the song are musical arranger Harry Simeone and composer Henry Onorati. The song is based on an old Czech carol and was originally titled "Carol of the Drum."

L'Enfant au Tambour

Venez on m'a dit
 Pa ram pam pam pam
Pour voir un roi nouveau-né
 Pa ram pam pam pam
Nos plus beaux cadeaux nous
apportons
 Pa ram pam pam pam
Pour déposer devant le roi
 Pa ram pam pam pam
 ram pam pam pam
 ram pam pam pam
Pour lui rendre hommage
 Pa ram pam pam pam
Quand nous venons
 Pam pam pam pam
Pa ram pam pam pam
Pam pam pam pam
Pam pam pam pam
 Pa ram pam pam pam

Pam pam pam pam
Petit bébé
 Pa ram pam pam pam
Je suis un pauvre garçon aussi
 Pa ram pam pam pam
Je n'ai pas de cadeau à apporter
 Pa ram pam pam pam
Qui soit digne de donner à notre roi
 Pa ram pam pam pam
 Ram pam pam pam
 Ram pam pam pam
Dois-je jouer pour vous
 Pa ram pam pam pam
 Pa ram pam pam
 Pam pam pam pam
Marie hocha la tête
 Pa ram pam pam pam
Le bœuf et l'agneau battaient la
mesure

 Pa ram pam pam pam
Je jouais mon tambour pour lui
 Pa ram pam pam pam
Je jouais de mon mieux pour lui
 Pa ram pam pam pam
 Ram pam pam pam
 Ram pam pam pam
Puis il me sourit
 Pa ram pam pam pam
Moi et mon tambour

Venez on m'a dit
 Pa ram pam pam pam
Pour voir un roi nouveau-né
 Pa ram pam pam pam
Moi et mon tambour
Moi et mon tambour
Moi et mon tambour
Moi et mon tambour
 Ram pam pam pam

"The Little Drummer Boy" est une chanson populaire de Noël qui aurait été écrite en 1941 par la compositrice américaine Katherine Kennicott Davis. Autres personnes associées à la chanson : Harry Simeone, arrangeur, et Henry Onorati, compositeur. La chanson est inspirée d'un vieux chant tchèque et a été initialement intitulée "Carol of the Drum".

Gifts to lay before the King

Many an autumn afternoon in the 1980s and '90s found Cajun artist Floyd Sonnier hard at work in the back room of his studio in Scott, Louisiana, just west of Lafayette. He was bent over his artboard applying ink to paper, creating a new piece of Christmas-themed art.

Christmastime held an extra special place in Floyd's heart and soul, as evidenced by the substantial body of work he produced over three decades, until his death in 2002. Naturally, he enjoyed drawing his own children with their Christmas toys. And he delighted in rendering Santa Claus in settings that were distinctively south Louisiana.

Floyd was a big believer in the true meaning of Christmas - and it shows in his drawings that include the Baby Jesus. He believed that Jesus is the Son of God, and that his purpose in coming to the Earth was to redeem humankind from sin, thus to facilitate our salvation and eternal happiness with God in Heaven. For Floyd, drawing the Christ Child - as well as Mary, Joseph, the angels and the three wise men - was an act of faith and love.

Floyd was known to listen to Christmas music for hours on end as his favorite holiday drew near. Christmas carols played in the background as he worked through his latest creation. Among his favorite tunes was "Little Drummer Boy," that time-honored, eloquent piece that strongly connects the secular world with the supernatural, evoking an extraordinary spirit of gratitude and adoration.

One can easily imagine that just as the little drummer boy would sing, "I play my drum for him, *Pa rum pum pum pum*," Floyd would be humming that same tune and thinking, *I draw my art for him, Pa rum pum pum pum.*

It's clear that Floyd relished the time he spent at his artboard drawing the Nativity scenes. He loved Christmastime and understood its true meaning. The art he created was the gift he humbly laid before the newborn King.

– *Trent Angers*

Les cadeaux déposés devant le Roi

Bien des après-midis d'automne, dans les années 1980 et 90, ça pouvait trouver l'artiste cadien Floyd Sonnier à son travail, dans la salle arrière de son studio de Scott en Louisiane, juste à l'ouest de Lafayette. Il était penché sur son tableau et après appliquer l'encre sur le papier, pour créer une nouvelle œuvre d'art sur le thème de Noël.

Noël tenait une place très spéciale dans le cœur et l'âme de Floyd, et ça se voit par la quantité d'œuvres d'art qu'il a produite pendant proche de trois décennies, jusqu'à sa mort en 2002. Bien sûr, il aimait dessiner ses propres enfants avec leurs jouets de Noël. Et il se plaisait à représenter le Père Noël dedans les milieux typiques du sud de la Louisiane.

Floyd était un grand croyant dans le vrai sens de Noël - et il le montre dans ses dessins qui incluent l'Enfant Jésus. Il croyait que Jésus était le Fils de Dieu, et que son but en venant sur la Terre était de racheter l'humanité du péché, afin de faciliter notre salut et le bonheur éternel avec Dieu au Ciel. Pour Floyd, dessiner l'Enfant Jésus - et aussi Marie, Joseph, les anges et les trois mages - était un acte de foi et d'amour.

Floyd était bien connu pour écouter de la musique de Noël pendant des heures alors que sa fête préférée approchait. Ça jouait des chants de Noël en fond sonore pendant qu'il travaillait à sa dernière création. Parmi ses chansons préférées y avait « L'Enfant au Tambour», ce morceau traditionnel et expressif qui relie fortement le monde séculier au surnaturel, évoquant un extraordinaire esprit de gratitude et d'adoration.

Ça se peut d'imaginer que, tout comme le petit joueur de tambour chante, « Je joue du tambour pour lui, Pa ram pam pam pam », Floyd était après chantonner la même mélodie en pensant, « je dessine mon art pour lui, Pa ram pam pam pam ».

Il est clair que Floyd savourait le temps qu'il passait sur son tableau à dessiner les scènes de la Nativité. Il aimait le temps de Noël et avait compris sa vraie signification. L'art qu'il créait était le cadeau qu'il déposait humblement devant le Roi nouveau-né.

FLOYD SONNIER '88
"TIMMY"

The true story of Christmas

Christmas is the birth date of Jesus Christ, the Son of God, who came into the world to redeem humankind from sin. He was conceived by the Holy Spirit and born of the Virgin Mary more than 2,000 years ago in a manger in Bethlehem. The story of his supernatural conception and birth is told in the Scriptures, most eloquently in the Gospel according to Luke.

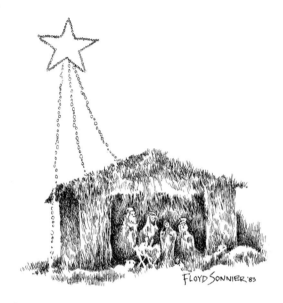

FLOYD SONNIER '83

God sent the angel Gabriel to a town in Galilee named Nazareth. He had a message for a girl promised in marriage to a man named Joseph, who was a descendant of King David. The girl's name was Mary.

The angel came to her and said:

"Peace be with you! The Lord is with you and has greatly blessed you!"

Mary was deeply troubled by the angel's message and she wondered what his words meant. The angel said to her:

"Don't be afraid, Mary; God has been gracious to you. You will become pregnant and give birth to a son, and you will name him Jesus. He will be great and will be called the Son of the Most High God. The Lord God will make him a king, as his ancestor David was, and he will be the king of the descendants of Jacob forever. His kingdom will never end!"

Mary said to the angel:

"I am a virgin. How, then, can this be?"

The angel answered:

"The Holy Spirit will come upon you, and God's power will rest upon you. For this reason the holy child will be called the Son of God. Remember your relative Elizabeth. It is said that she cannot have children, but she herself is now six months pregnant, even though she is very old. For there is nothing that God cannot do."

"I am the Lord's servant," said Mary, "may it happen to me as you have said."

And the angel left her.

* * * * *

At that time Emperor Augustus ordered a census to be taken throughout the Roman Empire. When this first census took place, Quirinius was the governor of Syria. Everyone, then, went to register himself, each to his own hometown.

Joseph went from the town of Nazareth in Galilee to the town of Bethlehem in Judea, the birthplace of King David. Joseph went there because he was a descendant of David. He went to register with Mary, who was promised in marriage to him. She was pregnant, and while they were in Bethlehem, the time came for her to have her baby. She gave birth to her first son, wrapped him in cloths and laid him in a manger. There was no room for them to stay in the inn.

There were some shepherds in that part of the country who were spending the night in the fields, taking care of their flocks. An angel of the Lord appeared to them, and the glory of the Lord shone over them.

They were terribly afraid, but the angel said to them:

"Don't be afraid! I am here with good news for you which will bring great joy to all the people. This very day in David's town your Savior was born – Christ the Lord! And this is what will prove it to you: You will find a baby wrapped in cloths and lying in a manger."

Suddenly a great army of heaven's angels appeared with the angel, singing praises to God.

"Glory to God in the highest heaven, and peace on earth to those with whom he is pleased!"

When the angels went away from them back into heaven, the shepherds said to one another:

"Let's go to Bethlehem and see this thing that has happened, which the Lord has told us."

So they hurried off and found Mary and Joseph and saw the baby lying in the manger. When the shepherds saw him, they told them what the angel had said about the child. All who heard it were amazed at what the shepherds said. Mary remembered all these things and thought deeply about them. The shepherds went back, singing praises to God for all they had heard and seen; it had been just as the angel had told them.

L'histoire vraie de Noël

*Noël est la date de naissance de Jésus-Christ, le Fils de Dieu, qui est venu
dans le monde pour racheter l'humanité du péché. Il a été conçu par le Saint
Esprit et né de la Vierge Marie il y a plus de 2000 ans dans une crèche
à Bethléem. L'histoire de sa conception surnaturelle et la naissance est dit
dans les Ecritures, la plus éloquente dans l'Évangile selon Luc.*

Dieu envoya l'ange Gabriel dans une ville de Galilée, appelée Nazareth. Il avait un message pour une fille promise en mariage à un homme nommé Joseph, qui était un descendant du Roi David. Le nom de la jeune fille était Marie. L'ange est venu vers elle et dit:

"Que la paix soit avec toi! Le Seigneur est avec vous et vous a grandement béni!"

Marie était profondément troublé par le message de l'ange et elle se demandait ce que ses mots signifiaient. L'ange lui dit:

"Ne crains point, Marie; Dieu a été miséricordieux pour vous. Vous allez devenir enceinte et donner naissance à un fils, et tu lui donneras le nom de Jésus. Il sera grand et sera appelé le Fils du Dieu. Le Seigneur Dieu lui faire roi, comme son ancêtre David était, et il sera le roi des descendants de Jacob éternellement. Son royaume ne finira jamais!"

Marie dit à l'ange:

"Je suis vierge. Comment, alors, peut-il être? "

L'ange lui répondit:

"Le Saint Esprit viendra sur toi, et Dieu pouvoir se reposer sur vous. Pour cette raison, le saint enfant sera appelé Fils de Dieu. Rappelez-vous votre parent Elizabeth. On dit qu'elle ne peut pas avoir des enfants, mais elle s'est maintenant enceinte de six mois, même si elle est très ancienne. Car il n'y a rien que Dieu ne peut pas faire."

"Je suis la servante du Seigneur", a déclaré Mary, "peut-il arriver à moi comme vous avez dit."

Et l'ange la quitta.

* * * * *

A cette époque, l'Empereur Auguste ordonna un recensement être prises tout au long de l'Empire Romain. Lorsque ce premier recensement a eu lieu, Quirinius était gouverneur de Syrie. Tout le monde, alors, est allé à enregistrer lui-même, chacun dans sa ville natale.

Joseph a quitté la ville de Nazareth en Galilée à la ville de Bethléem en Judée, berceau du roi David. Joseph y est allé parce qu'il était un descendant de David. Il est allé à inscrire avec Marie, qui a été promise en mariage à lui. Elle était enceinte, et alors qu'ils étaient à Bethléem, le temps est venu pour elle d'avoir son bébé. Elle a donné naissance à son premier fils, l'emmaillota et le coucha dans une crèche. Il n'y avait pas de place pour eux de rester dans l'auberge.

* * * * *

Il y avait des bergers dans cette partie du pays qui ont passé la nuit dans les champs, en prenant soin de leurs troupeaux. Un ange du Seigneur leur apparut, et la gloire du Seigneur resplendit sur eux. Ils étaient terriblement peur, mais l'ange leur dit:

"Ne pas avoir peur! Je suis ici avec de bonnes nouvelles pour vous, qui apportera une grande joie à tous les gens. Ce jour-là dans la ville de David, ton Sauveur est né - Christ le Seigneur! Et voici ce qui va vous le prouver: vous trouverez un enfant emmailloté et couché dans une crèche".

Soudain, une grande armée des anges du ciel est apparu avec l'ange, chantant les louanges de Dieu.

"Gloire à Dieu au plus haut des cieux, et paix sur la terre à ceux avec qui il est heureux!"

Lorsque les anges les eurent quittés pour retourner au ciel, les bergers se dirent les uns aux autres:

"Allons à Bethléem et voyons ce qui est arrivé, que le Seigneur nous a dit."

Ils se sont dépêché et trouvèrent Marie et Joseph, virent le petit enfant couché dans la crèche. Quand les bergers le virent, ils leur ont dit ce que l'ange avait dit à propos de l'enfant. Tous ceux qui les entendirent furent étonnés de ce que disaient les bergers. Marie se souvint toutes ces choses et pensait profondément à leur sujet. Les bergers retournèrent, chantant des louanges à Dieu pour tout ce qu'ils avaient entendu et vu; il avait été tout comme l'ange leur avait dit.

Acknowledgements

The Family of Floyd Sonnier (1933-2002) acknowledges with gratitude the people who supported and encouraged Floyd in his career as an artist, as well as those who helped to bring this book to fruition.

• Don Capretz and John Weinstein, close friends of Floyd's who have continued to support the Gallery and spread Floyd's art far and wide.

• Beverly Spell and Dr. Annie W. Spell of Ballet Acadiana, who sparked a renewal of interest in Floyd's work when they spearheaded the creation and production of a first-class ballet, titled *Le Papillon: Celebrating Floyd Sonnier's Acadiana*, which premiered in 2016.

• Kathleen Sonnier Mier, Floyd's sister, for her long-term support and promotion of the Cajun culture and her dedication to continuing her brother's legacy.

• Bryan Theriot of Gallery Acadie, an accomplished artist who has shown great respect for Floyd's work and who continues to support our Gallery in numerous ways.

• Dr. Michael Vincent, who, with the able assistance of Maggie Perkins and Christophe Pilut, translated much of the English text in this book into French. (He and his team translated all except the Christmas greetings that accompany the major art; those were translated by Floyd between 1980 and 2001.)

• The staff of Acadian House Publishing (Trent Angers, Charlotte Huggins, Darlene Smith and Alex Angers) for their tireless efforts to make this book a fitting tribute to Floyd and the art he created.

– Verlie Sonnier (Mrs. Floyd Sonnier)
and children, Gil, Mark, Tim and Annette

Reconnaissances

La famille de Floyd Sonnier (1933-2002) reconnaît avec gratitude les personnes qui ont soutenu et encouragé Floyd dans sa carrière d'artiste, ainsi que ceux qui ont aidé à réaliser ce livre.

• Don Capretz et John Weinstein, des amis proches de Floyd qui ont continué à soutenir la galerie et à diffuser largement les œuvres de Floyd.

• Beverly Spell et Dr. Annie W. Spell du Ballet Acadiana, qui ont suscité un renouveau d'intérêt pour le travail de Floyd quand elles ont dirigé la création et la production d'un ballet de première classe, intitulé *Le Papillon: Celebrating Floyd Sonnier's Acadiana*, dont la première était en 2016.

• Kathleen Sonnier Mier, la soeur de Floyd, pour son soutien au long terme et la promotion de la culture cadienne ainsi que son dévouement à poursuivre l'héritage de son frère.

• Bryan Theriot de Gallery Acadie, un artiste accompli qui a montré un grand respect pour le travail de Floyd et qui continue à soutenir notre galerie de nombreuses façons.

• Dr. Michael Vincent, qui, avec l'aide de Maggie Perkins et Christophe Pilut, a traduit une grande partie du texte anglais dans ce livre en français (lui et son équipe ont tout traduit, sauf les salutations de Noël qui accompagnent l'art majeur; qui ont été traduites par Floyd entre 1980 et 2001).

• Le personnel de Acadian House Publishing (Trent Angers, Charlotte Huggins, Darlene Smith et Alex Angers) pour leurs efforts inlassables pour faire de ce livre un hommage approprié à l'art de Noël de Floyd.

– Verlie Sonnier (Mme Floyd Sonnier)
et les enfants, Gil, Mark, Tim and Annette

Table of Contents

◆

Table des matières

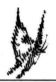

Butterflies everywhere!

If you look closely, you'll see a butterfly in each of the drawings in this book. The artist included them as a symbol of the re-birth and renewal of pride in the French-Acadian, or Cajun, language and culture of south Louisiana.

And, by the way, a top-flight ballet, which premiered in 2016, drew its name from this butterfly (*le papillon*) and its inspiration from the life and works of the artist. The ballet is titled *Le Papillon: Celebrating Floyd Sonnier's Acadiana*. For more information, go to www.balletacadiana.org.

* * *

Des papillons partout !

Si tu regardes attentivement, tu vas voir un papillon dans chacun des dessins de ce livre. L'artiste les a inclus comme un symbole de la renaissance et du renouveau de fierté dans le français acadien, ou cadien, de la langue et de la culture du sud de la Louisiane.

D'ailleurs, un ballet de haute qualité, dont la première était en 2016, tire son nom de ce papillon et son inspiration de la vie et des œuvres de l'artiste. Le ballet est intitulé *Le Papillon: Celebrating Floyd Sonnier's Acadiana*. Pour plus d'informations, allez à www.balletacadiana.org.

The Christmas Cards

The images on the following pages
(16 - 63) and corresponding Christmas
greetings were created by Floyd Sonnier
and originally published in the form of
Christmas cards, between 1980 and 2001.

Les cartes de Noël

*Les images sur les pages suivantes (16 - 63)
et les vœux de Noël correspondants ont été créés par
Floyd Sonnier et publiés à l'origine sous la forme de
cartes de Noël, entre 1980 et 2001.*

Sing a song of glory,
sing a song of joy,
rejoice in His birth,
Jesus, the baby boy.
May the love and joy
of Christmas
be with you.
Merry Christmas

Chantez un chant glorieux,
chantez un chant joyeux,
réjouissez-vous de sa naissance
Jésus, le petit enfant.
que l'amour et la joie de Noël
soient avec vous.
Joyeux Noël!

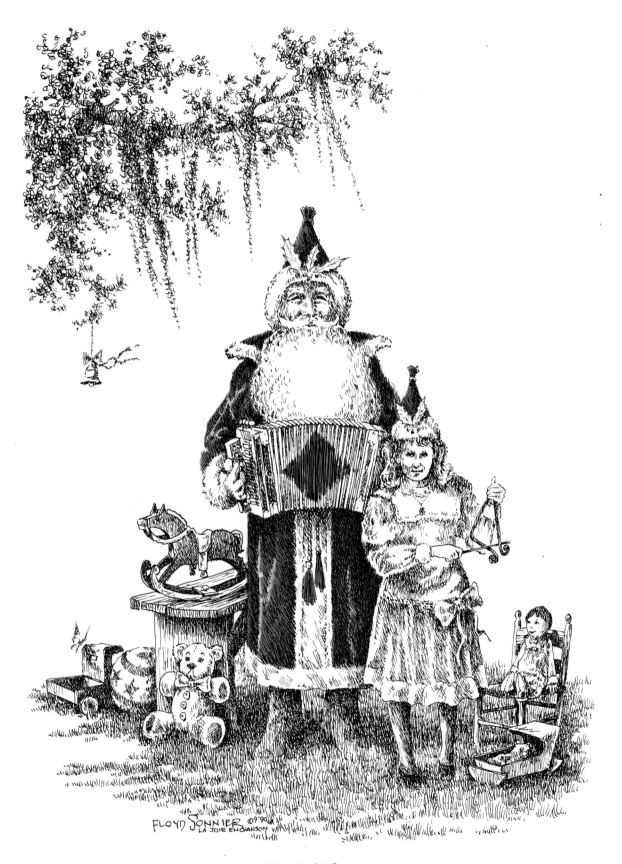

The Joyful Song

La Joie en Chanson

All the little animals
gather around Santa
to honor the birth of Jesus on this day.
May you and your friends
remember the joy of the season
and the holiness of His day.
Merry Christmas

Tous les petits animaux
Se rassemblent ce jour-ci autour du Saint-Nicholas
Pour honorer la naissance du Jésus.
Que vous et vos amis
Se souviennent de la joie de la saison
et de la sainteté de son jour.
Joyeux Noël

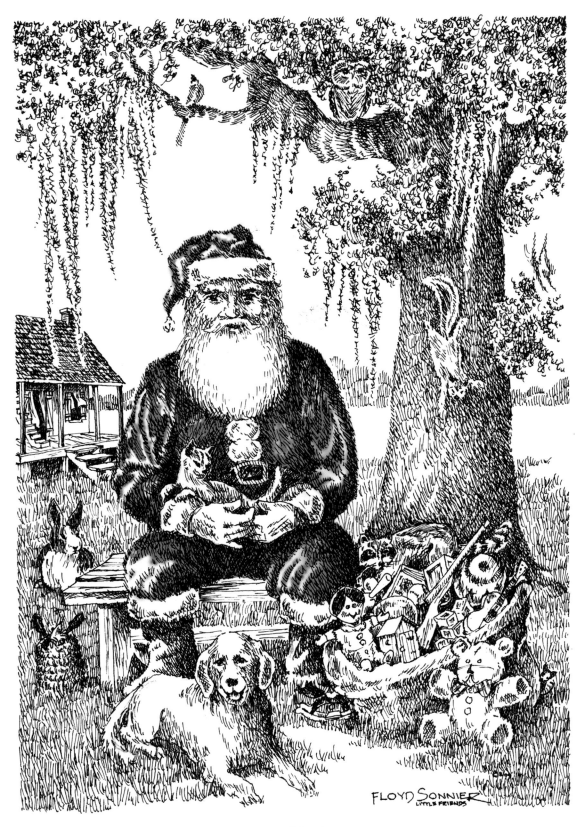

Little Friends

Petits Amis

Christmas Gumbo...
A mixture of joy & peace,
hope and happiness,
sprinkled with lots of love...
be yours
throughout this Holy Season.
Merry Christmas

Un gombo de Noël...
Un mélange de joie et de paix,
d'espoir et de bonheur,
saupoudré de beaucoup d'amour...
pour vous pendant cette Sainte Saison.
Joyeux Noël

Christmas Gumbo

Gombo de Noël

...And the child
shows us peace and glory
towards each other
through her innocence
and by her love.
Merry Christmas

...Et l'enfant
nous montre la paix et la gloire
vers l'une et l'autre
par son innocence et
son amoure.
Joyeux Noël

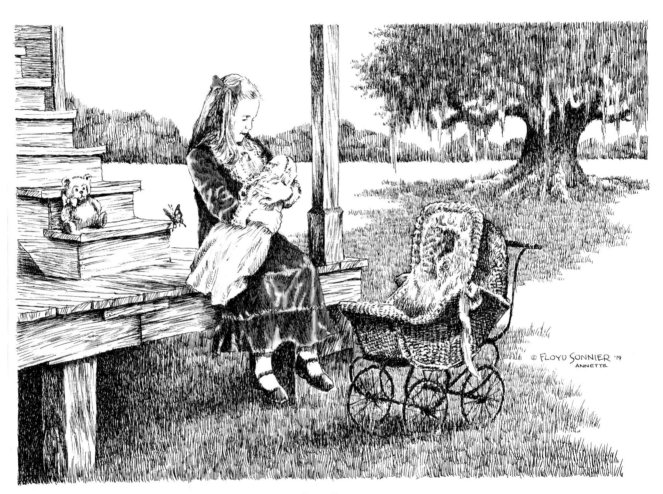

Annette

The Little Drummer Boy
Pa-rum-pum-pum,
pa-rum-pum-pum!
He played with all the love
in his heart.
Baby Jesus smiled.
Merry Christmas

Le Petit Joueur de Tambour
Pa-rum-pum-pum,
pa-rum-pum-pum!
Il jouait de tout son coeur.
Et le petit Jesus souriait.
Joyeux Noël

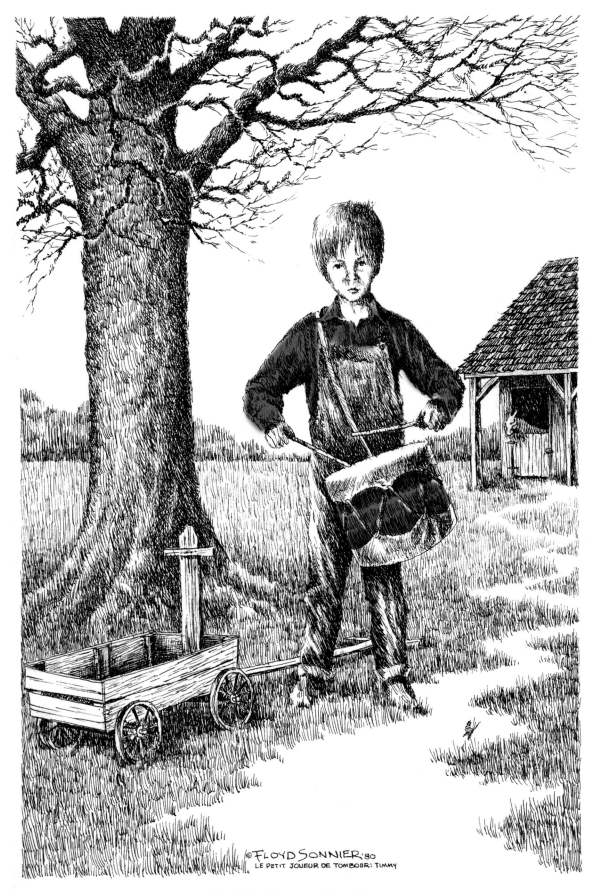

The Little Drummer Boy: Timmy

Le Petit Joueur de Tambour: Timmy

A loving mother
gave us her Christ Child
to show us a life
of love and truth
through His glory.
Merry Christmas

*Une mère dévouée
nous donne son enfant Christ
pour nous montrer la vie
d'amoure et de vérité
par sa gloire.
Joyeux Noël*

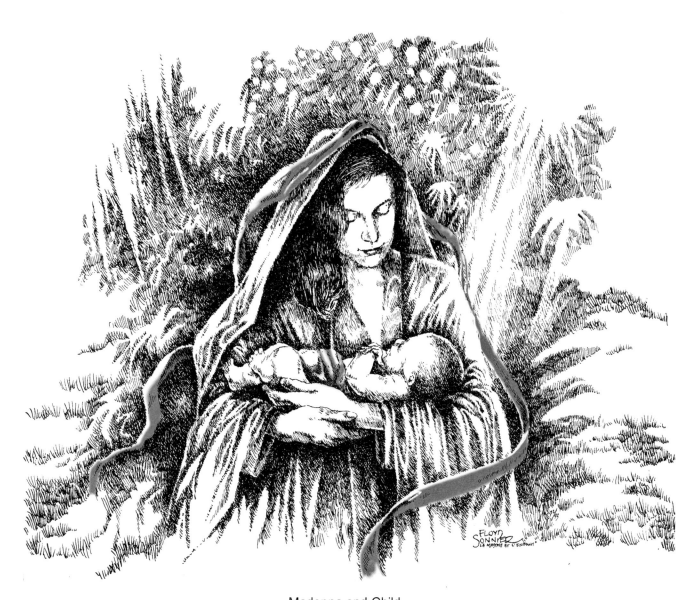

Madonna and Child

La Madone et L'Enfant

Creatures of the bayou
gather with joy,
for the spirit of giving
is near.
May the calmness
of the bayou
reflect the spirit
of Christmas in your heart.
Merry Christmas

*Les créatures du bayou
se rassemblent dans la joie
car l'esprit de la fête
approche.
Que le bayou paisible
reflète l'esprit de Noël
dans votre coeur.
Joyeux Noël*

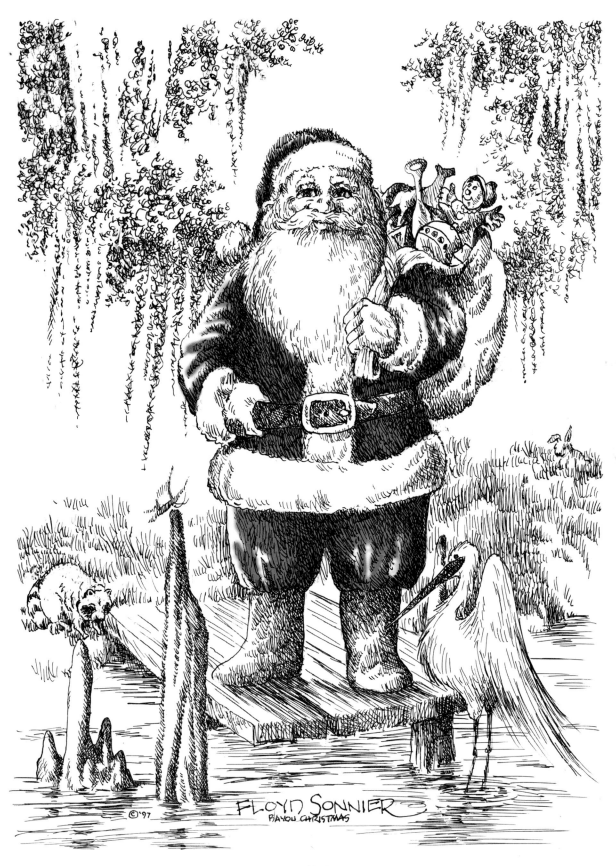

Bayou Christmas

Noël de Bayou

May the mystic
of the swamps
and the spirit
of the animals
bring you joy and peace
throughout the year.
Merry Christmas

*Puissent le mystique
des marécages
et l'esprit
des animaux
vous apportent
de la joie et de la paix
pendant toute cette sainte saison.
Joyeux Noël*

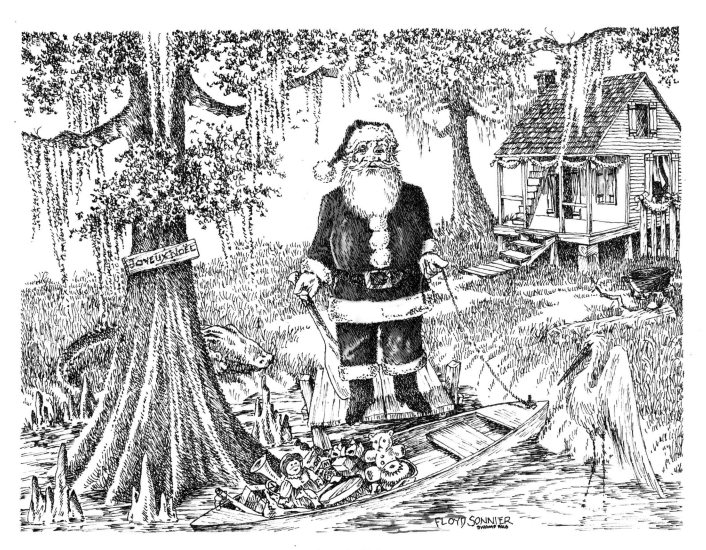

Swamp Pals

Camarades de Marais

May the spirit of the bayou
bring you happiness
and joy
this Christmas
and throughout the year.
Merry Christmas

*Que l'exprit du bayou
vous apporte
bonheur et joie ce Noël
et pendant toute l'année.
Joyeux Noël*

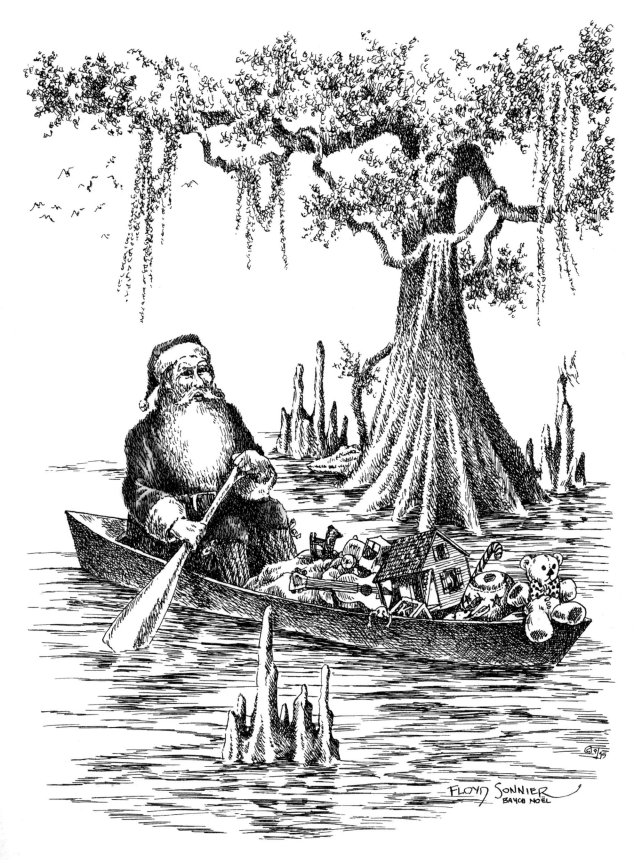

Christmas Bayou

Bayou de Noël

May the child Jesus,
who is the joy of all the Earth,
turn his loving gaze on you
and bring you peace and hope!
Merry Christmas

Que l'enfant Jésus,
qui est la joie de tout le monde,
vous render sa vue tendre
et vous opporte la paix et l'espoir!
Joyeux Noël

Santa Claus is…a child's imagination

Papa Noël est… l'imagination d'un enfant

The lamb and the child
praise the Baby Jesus,
seeking love and peace
for each of us.
And the whole world shall be
better for it.
Merry Christmas

Le petit mouton et l'enfant
glorifient le Bébé Jésus,
en cherchant l'amour
et la paix,
pour chaqué un de nous.
et tout le monde entire
serait tant mieux.
Joyeux Noël

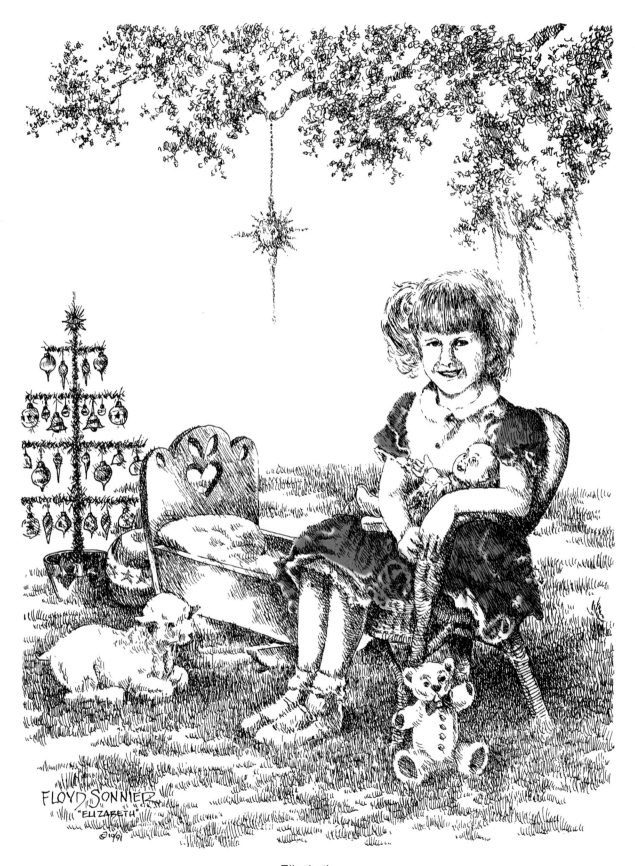

Elizabeth

It's Christmas time
in the swamps
and the Heavens
are starry and bright.
The critters and creatures
are all alive
with the joy of this
most Holy Night.
Merry Christmas

C'est Noël dans les marais
et le ciel est plein
d'étoiles et de lumière.
Toutes les créatures
sont pleines de vie
et remplies de la joie de cette
très Sainte Nuit.
Joyeux Noël!

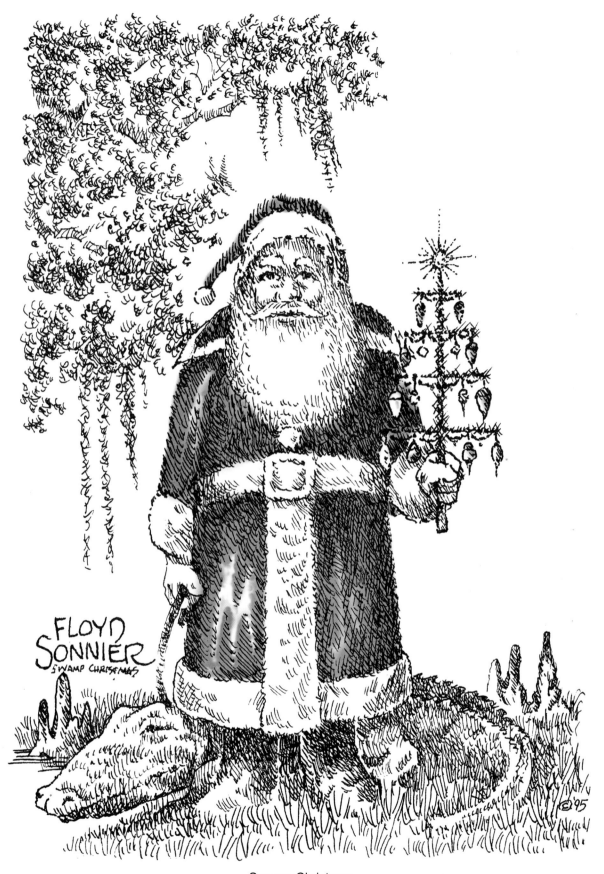

Swamp Christmas

des marécages de Noël

Holiday gifts are fun to remember...
like the laughter and joy
of a merry, old-fashioned December.
May His joy be in your Christmas.
Merry Christmas

*Les cadeaux de Noël
sont amusand de se souvenir ...
comme les farces et les joies
d'un Decembre joyeux et
à la vielle mode.
Que son joie soit dans votre Noël.
Joyeux Noël*

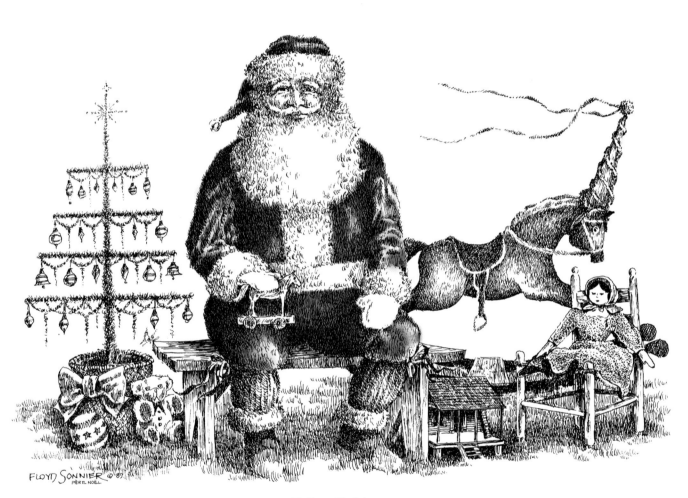

Father Christmas

Père Noël

Sing us a happy song, y'all.
Fill the hearts of
every little girl and boy
with a song of love
and with a song of joy.
Merry Christmas

Chantez-nous une chanson heureuse,
vous autres.
Remplissez les coeurs de
chaque petite fille et chaque petit garçon
avec une chanson d'amour
et avec une chanson de joie.
Joyeux Noël

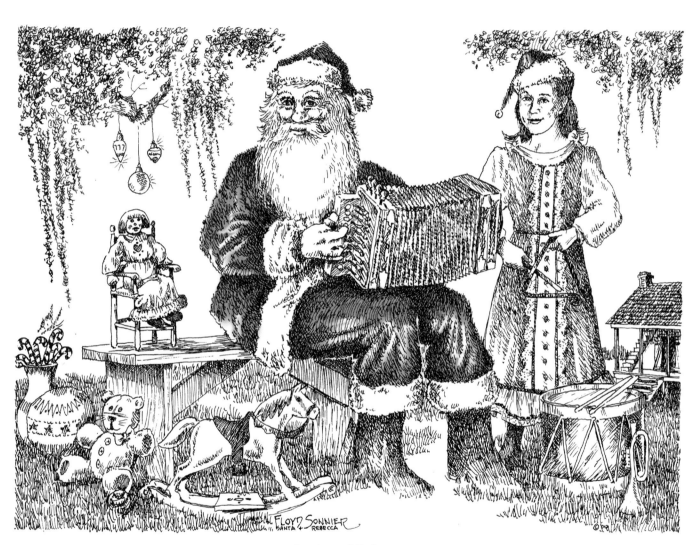

Santa and Rebecca

Papa Noël et Rébecca

May the spirit of Christmas,
which is peace,
the gladness of Christmas,
which is hope,
the heart of Christmas,
which is love,
be with you.
Merry Christmas

Que l'esprit de Noël,
qu'est la paix,
la joie de Noël,
qu'est l'espoir,
le coeur de Noel,
qu'est l'amour,
soit être avec vous.
Joyeux Noël

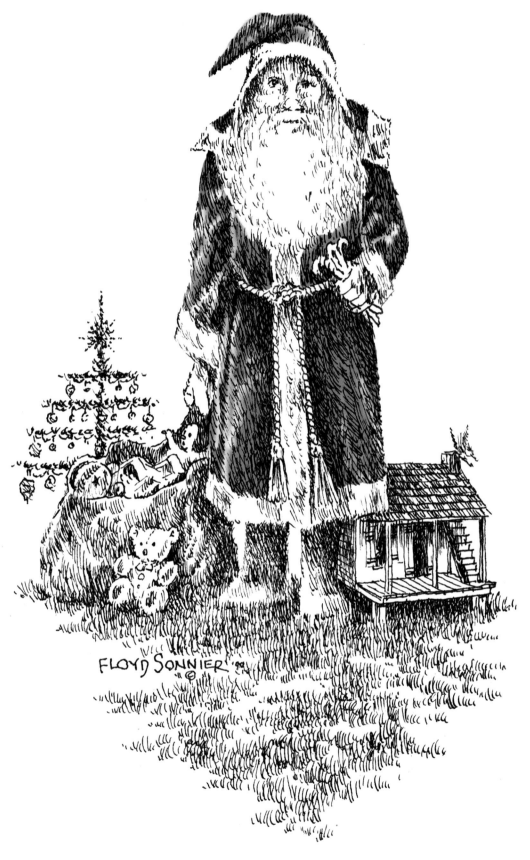

Santa Claus

Père Noël

Our Christmas gift to you
is our love
and the love of the
Christ Child.
May it make this Christmas
the happiest one ever.
Merry Christmas

*Nos cadeau de Noël à vous
est notre amour
et l'amour de
l'enfant Christ.
Que ça fais cette Noël,
le plus heureux toujours.
Joyeux Noël*

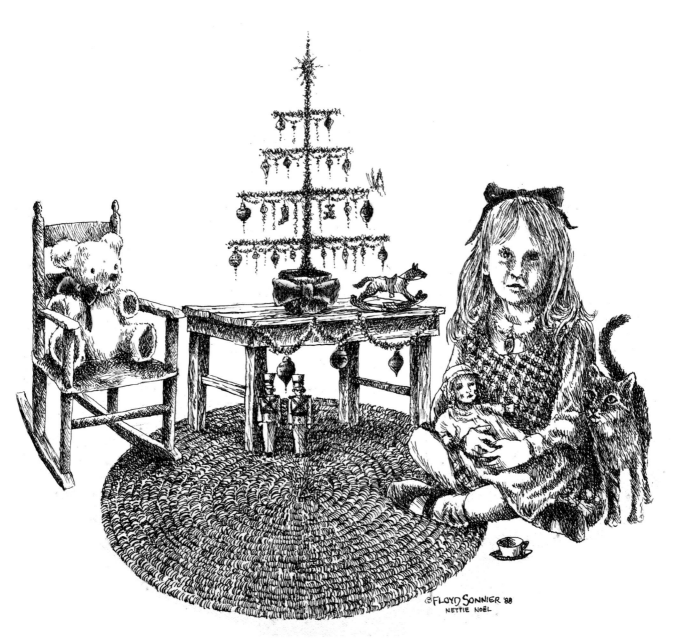

Nettie Noël

Jesus came to us as a child
with gifts of love and peace.
May the joy of these gifts
be with you!
Merry Christmas

L'enfant Jésus est venu a nous
avec des cadeaux d'amour et de paix.
Que la joie de ces cadeaux
soit avec vous!
Joyeux Noël

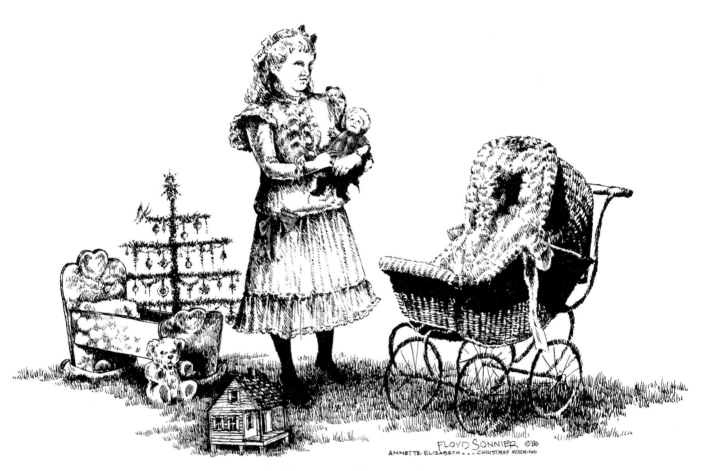

Annette Elizabeth.... Christmas Morning

Annette Élisabeth... le matin de Noël

The Christ Child
came into this world
to bring love
and happiness
every day of the year.
Merry Christmas

L'Enfant Jésus
est venu au monde
pour apporter de l'amour
et du bonheur
chaque jour de l'année.
Joyeux Noël

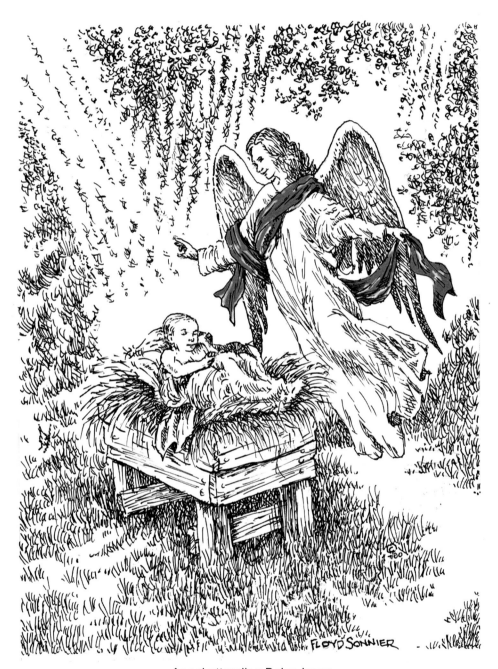

Angel attending Baby Jesus

L'Ange après servir l'Enfant Jésus

It's the day before Christmas,
and the buggy's loaded down,
St. Nicholas and Betsy
are ready to make their round,
bringing love and happiness
and plenty of joy
to every little Cajun
girl and boy.
Merry Christmas

C'est le jour avant Noël,
et le boghet est tout charger,
St. Nicholas et Betsy sont pare's
a aller faire leur tour,
pour amener de l'amour,
la félicité
et l'abondance de joie
a chacque petit garçon Cadjin
et petite fille Cadjine.
Joyeux Noël

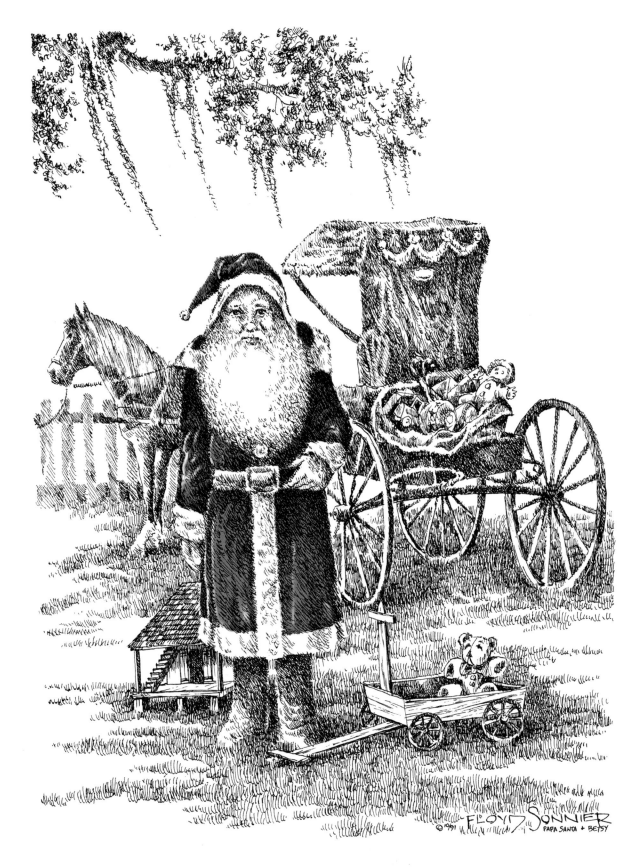

Papa Santa & Betsy

Papa Noël et Betsy

May the joy of Christmas,
as seen through the laughter
of the little children,
bring peace and happiness
in your heart during
this Holy Season.
Merry Christmas

En cette Sainte Saison
que la joie de Noël
a travers le rire des enfants,
apporte paix bonheur
dans votre coeur.
Joyeux Noël

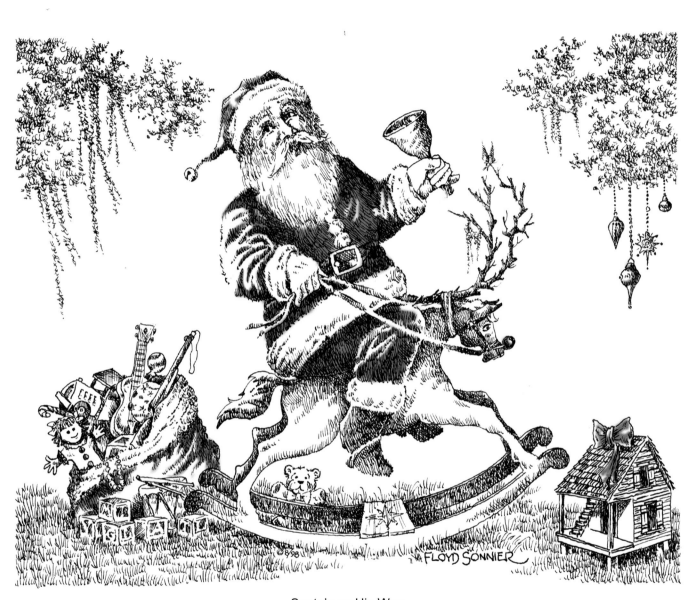

Santa's on His Way

Papa Noël s'en vient

May the magic of the Cajun prairie
at Christmas time
bring a spirit of joy,
of peace and of hope
throughout your year.
Merry Christmas

Que l'enchantement
du prairie Cadjin
durant la saison
de Noel
amene l'esprit
de joie, de paix
et d'espoire
pendant tout votre annee.
Joyeux Noël

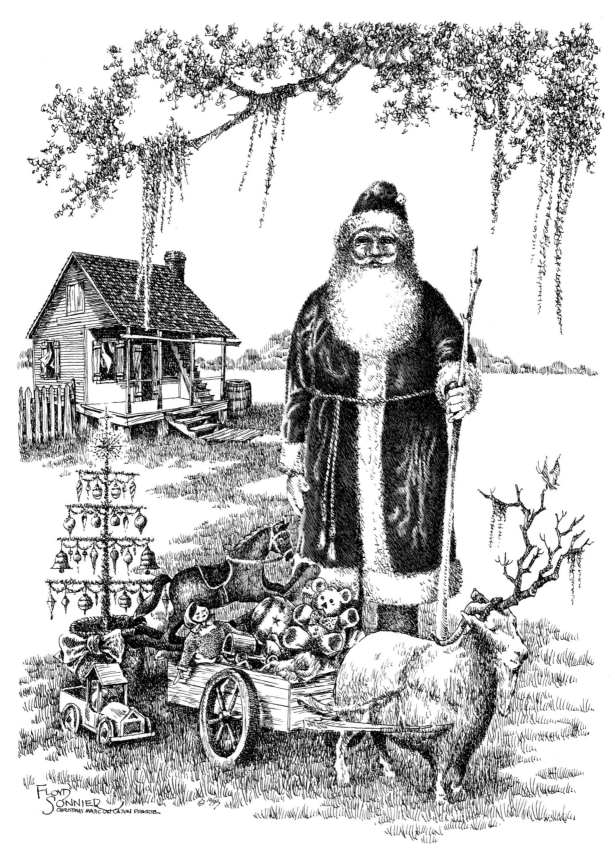

Christmas Magic on the Cajun Prairie

La magie de Noël sur la prairie Cadienne

May the love
for the Christ Child,
embraced by the joy
of this holy season,
bring happiness and peace
to every day of your life.
Merry Christmas

*Que l'amour du Divin enfant
et la joie de cette saison sainte,
apportent paix et bonheur
chaque jour de votre vie.
Joyeux Noël*

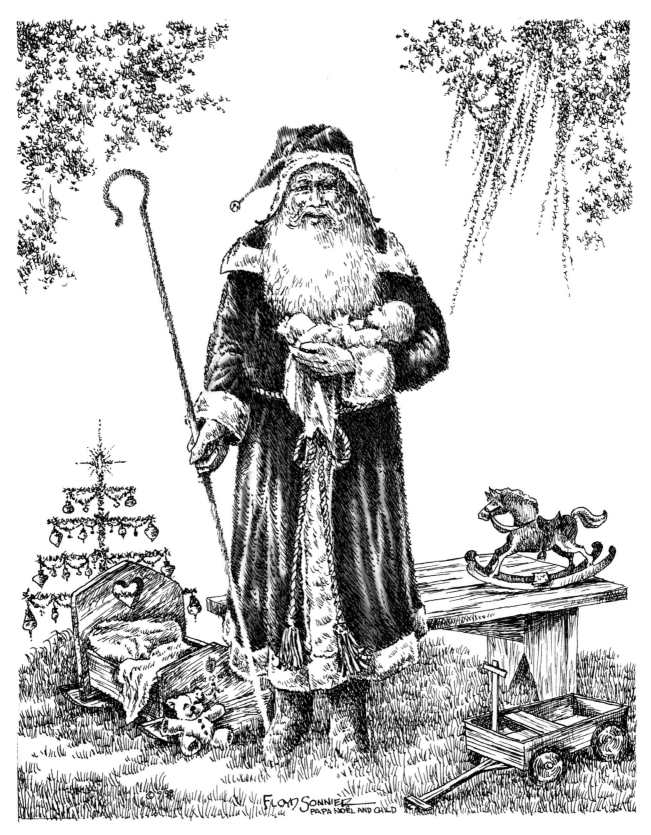

Papa Noël & Child

Papa Noël et Enfant

The happiness and joy
of the little children
are reflected in their faces
on Christmas morn.
The toymaker's bountiful glory
is in the gifts he shares
on this, the glorious day
our Lord was born.
Merry Christmas

Le bonheur at la joie
des petits enfants
sont réfléchis dans leurs visages
le matin de Noël.
La gloire généreuse du faiseur de jouets
est dans les cadeaux qu'il partage
sur ce jour glorieux de
la naissance de notre Seigneur.
Joyeux Noël

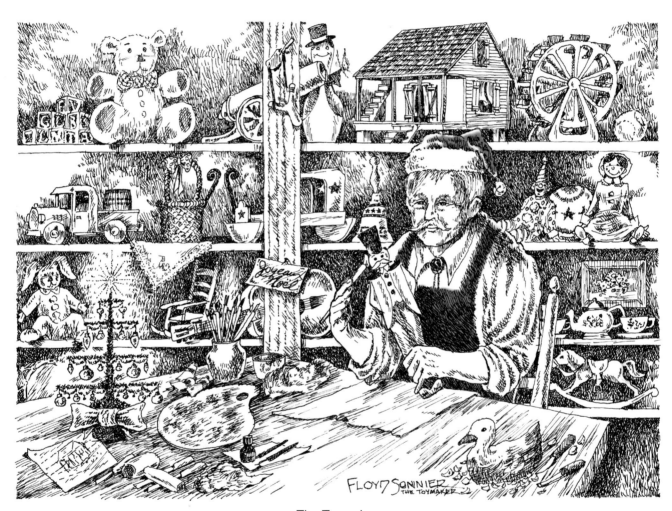

The Toymaker

Le faiseur de jouets

May the New Year
bring peace to the world
and happiness, good health
and prosperity
to you and your family.

Que la nouvelle année
Apporte la paix dans le monde,
le bonheur, la bonne santé
et la prospérité
pour toi et ta famille.

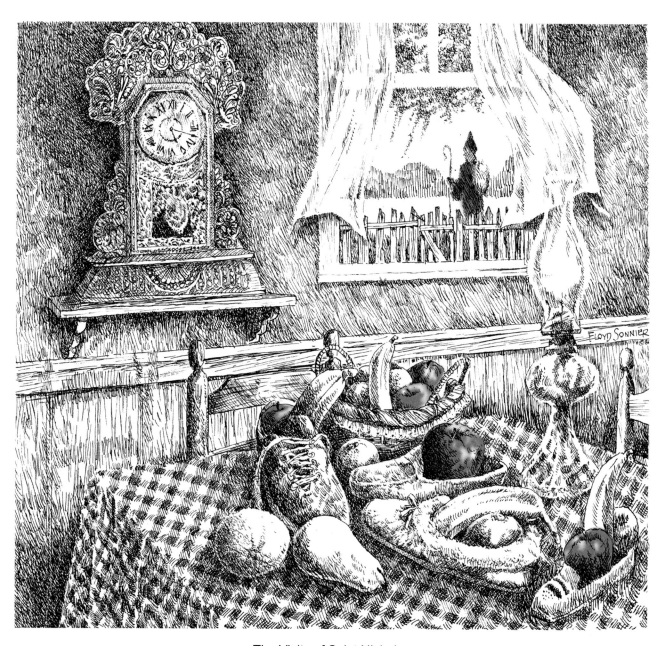

The Visits of Saint Nicholas

Les visites du Saint Nicolas

FLOYD SONNIER '84

The Ornaments / Les ornements

A Christmas tradition that Floyd Sonnier enjoyed for two decades (1981-2001) was to have Christmas ornaments made that bore his artwork. The white ceramic ornaments – in the shape of bells, stars, circles, etc. – were sold and hung on Christmas trees and mantels of many a home in south Louisiana during the Holiday Season.

Une tradition de Noël que Floyd Sonnier a connu depuis deux décennies (1981-2001) était d'avoir des décorations de Noël faites qui portaient ses œuvres. Les ornements en céramique blanche - en forme de cloches, étoiles, cercles, etc. - ont été vendus et accrochés sur les arbres de Noël et mantels de nombreux foyers dans le sud de la Louisiane pendant la saison des Fêtes.

 *

1981

 *

1982

 *

1983

 *

1984

 *

1985

* The 11 ornaments marked with asterisks (*) were commissioned by the Junior League of Lafayette and sold as part of fundraisers in support of Acadian Village and its Holiday Season event called "Christmas Comes Alive."

** Les 11 ornements marqués d'un astérisque (*) ont été commandées par la Ligue junior de Lafayette et vendus dans un bénéfice à l'appui de Acadian Village pendant la saison des fêtes et son événement appelé "Christmas Comes Alive."*

1986

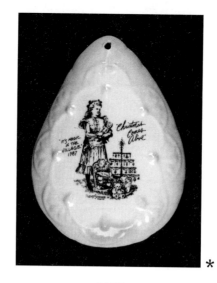

1987

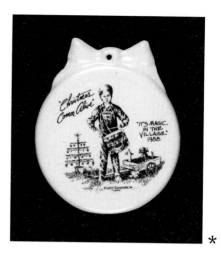

1988

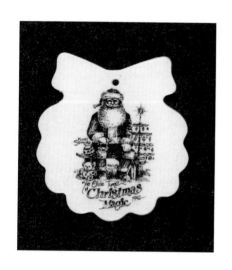

1992

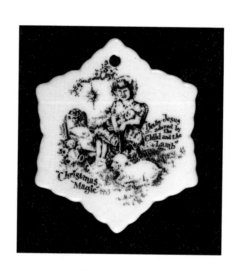

1993

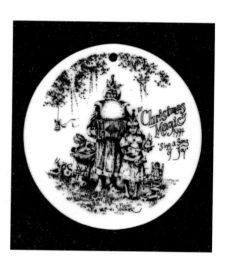

1994

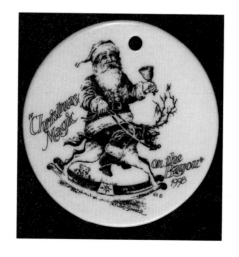

1998

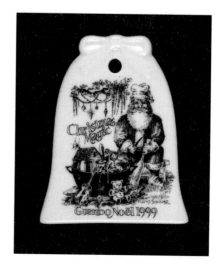

1999

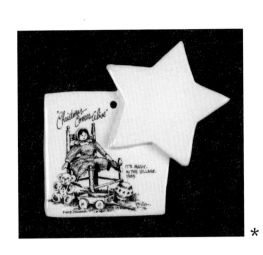

*

1989

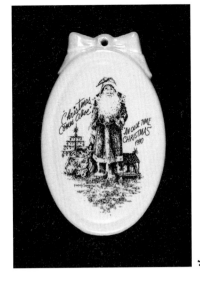

*

1990

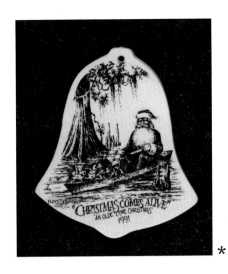

*

1991

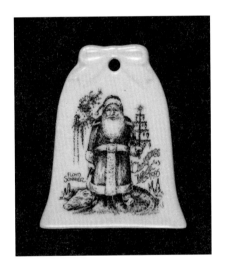

1995

1996

1997

2000

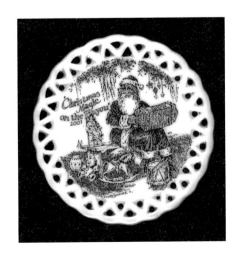

2001

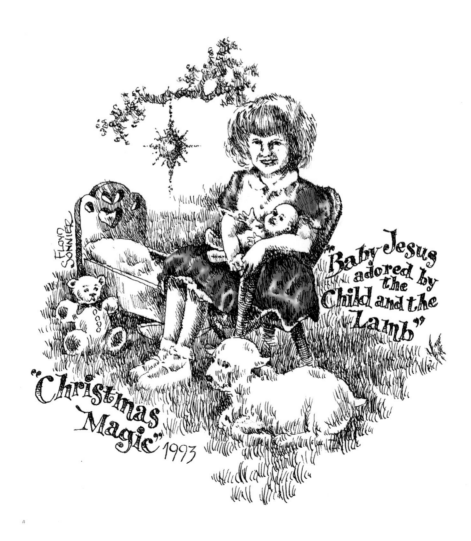

"Christmas Magic" 1993

"Baby Jesus adored by the Child and the Lamb"

Index of Art
(By title)

Indice d'Art
(Par titre)

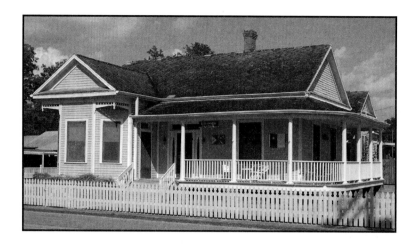

Beau Cajun Gallery

Founded in 1980 by Floyd Sonnier as Beau Cajun Art Gallery and Studio, the Gallery is operated by Floyd's widow, Verlie Sonnier.

Located today at 1010 St. Mary Street in downtown Scott, Louisiana (5 miles west of Lafayette and just 4 blocks from Interstate 10), the Gallery occupies a beautiful Victorian house constructed in 1918 and furnished with primitive Louisiana antiques. In this old house, one can enjoy nostalgic feelings of turn-of-the-century life on the Cajun prairie.

The Gallery offers a range of top-quality merchandise for sale:

- Limited Edition Prints
- Original Works of Art
- Christmas Cards
- Calendars
- Posters (*Festivals Acadiens* and Cajun French Music Association)
- Books (*From Small Bits of Charcoal: The Life & Works of a Cajun Artist, CHRISTMAS in Cajun Country, Growing Up in South Louisiana, Tell Me More* (Junior League Cookbook), and several more).

www.floydsonnier.com

Fondée en 1980 par Floyd Sonnier comme galerie d'art et studio Beau Cajun, la galerie est opérée par la veuve de Floyd, Verlie Sonnier.

Situé au 1010 St. Mary Street, dans le centre Scott, en Louisiane (5 miles à l'ouest de Lafayette et à seulement 4 pâtés de maisons de l'Interstate 10), la galerie occupe une belle maison victorienne construite en 1918 et meublée avec des antiquités primitives de la Louisiane. Dans cette ancienne maison, on peut ressentir la nostalgie de la vie dans la prairie cadienne au tournant du siècle.

La galerie propose à la vente une gamme de marchandises de qualité supérieure:

- Impressions en tirage limité
- Oeuvres d'art originales
- Cartes de Noël
- Calendriers
- Posters (Festivals Acadiens et Cajun French Music Association)
- Livres (*From Small Bits of Charcoal: The Life & Works of a Cajun Artist, CHRISTMAS in Cajun Country, Growing Up in South Louisiana, Tell Me More* (Junior League Cookbook), et plusieurs autres).

About the Artist...

FLOYD SONNIER (1933-2002), known to many as "The Artist of the Cajuns," was a lifelong resident of the Cajun Country of south Louisiana. An internationally acclaimed pen-and-ink artist, he graduated in commercial art from the University of Southwestern Louisiana in Lafayette in 1961 after serving a brief stint in the U.S. Army. In a prolific career that spanned a quarter of a century, he specialized in drawings that depict life in the old-time Cajun culture, particularly scenes set in the first half of the Twentieth Century.

A native of the Pointe Noire community near Church Point, La., he was married to Verlie Gay of Church Point in 1965. They have four children, Gil, Mark, Tim and Annette.

Au sujet de l'artiste...

FLOYD SONNIER (1933 - 2002), connu comme «l'Artiste des Cadjins,» était habitant pour toute sa vie du Pays Cadjin du sud de la Louisiane. Artiste à la plume de renom international, il a obtenu son diplôme de l'Université du Sud-Ouest de la Louisiane à Lafayette en 1961 après avoir servi dans l'armée des États-Unis. Au cours d'une carrière prolifique qui a duré un quart de siècle, il était spécialiste des dessins de la vie de la culture cadjinne, particulièrement des scènes de la première partie du vingtième siècle.

Originaire de la communauté de la Pointe Noire près de la Pointe de l'Église en Louisiane, il s'est marié à Verlie Gay de la Pointe de l'Église en 1965. Ils ont quatre enfants: Gil, Mark, Tim et Annette.

– Photography by Danny Izzo,
Nouveau Photeau,
Lafayette, Louisiana

Regional Books
About *Intriguing*
South Louisiana

CHRISTMAS in Cajun Country

A 72-page hardcover book that displays the Christmas-themed drawings of pen-and-ink artist Floyd Sonnier. The main feature of the book is the art and corresponding Season's Greetings that were originally published as Christmas cards between 1980 and 2001. The book reflects the late Mr. Sonnier's love of Christmastime and his firm belief in the true meaning of Christmas. (Author & Artist: Floyd Sonnier. ISBN: 0-925417-86-6. Price: $29.95)

Growing Up in South Louisiana

A 176-page hardcover book describing what life was like growing up in south Louisiana in the 1930s, '40s, '50s and '60s. Some 20 authors help paint the picture: eating Sunday dinner at grandma's, hearing Cajun French spoken in the home, working on the farm before school, attending *fais do dos* and *boucheries*, chewing sugarcane, etc. Illustrated with photos and drawings. (Editor: Trent Angers. ISBN: 0-925417-35-1. Price: $17.95.)

The Nature Of Things At LAKE MARTIN
Exploring the wonders of Cypress Island Preserve in southern Louisiana

A 128-page hardcover book describing the 9,300-acre preserve that includes one of the most impressive wading bird rookeries in North America. Beautifully illustrated with photographs of birds, alligators, furry animals and people who live here, as well as pictures of the woods and waters of the area. The book has two maps, lists of the 200-plus birds that have been seen here, and tips on photographing birds and other animals. (Photographer/Author: Nancy Camel. ISBN: 0-925417-54-8. Price: $44.95)

The Terrible Storms of 2005
Hurricane Katrina and Hurricane Rita

A 184-page book about the 2 devastating hurricanes that struck Louisiana in 2005 – and the heroic efforts of many to rescue victims of the storms. Katrina was "the worst natural disaster in U.S. history," leaving New Orleans severely flooded and more than 1,800 people dead. Rita leveled Cameron, La., and led to the deaths of dozens of evacuees fleeing the storm in nearby southeast Texas. Illustrated with 32 pages of color photos, plus maps. The book also features a special section on pet rescues. (Editor: Trent Angers. Hardcover ISBN: 0-925417-94-7. Price: $17.95.)

From Small Bits Of Charcoal:
The Life & Works of a Cajun Artist

This 190-page hardcover book is the autobiography of pen-and-ink artist Floyd Sonnier (1933-2002) of Lafayette, La. Written and illustrated by Mr. Sonnier, the book tells the story of growing up as a French-speaking Cajun in rural south Louisiana in the 1940s and '50s. It is a testament to his love of his French-Acadian, or Cajun, culture and heritage. (Author & Artist: Floyd Sonnier. ISBN: 0-925417-46-7. Price: $59.95)

Louisiana Sugarcane Pictorial
From the Field to the Table

A 112-page hardcover book of top-notch photographs depicting virtually every aspect of the south Louisiana sugarcane industry – from planting and harvesting the crop to milling and refining the cane. Also featured are aerial photos of all 11 mills operating in this region, as well as rare pictures of old machinery and buildings that served the industry in a bygone era. (Photographer/Author: Ronnie Olivier. ISBN: 0-925417-93-9. Price $34.95)

Grand Coteau
The Holy Land of South Louisiana

A 176-page hardcover book that captures the spirit of one of the truly holy places in North America. It is a town of mystery, with well-established ties to the supernatural, including the famous Miracle of Grand Coteau. Brought to life by dozens of exceptional color photographs, the book focuses on the town's major religious institutions: The Academy of the Sacred Heart, Our Lady of the Oaks Retreat House and St. Charles College/Jesuit Novitiate. The book explores not only the history of these three institutions but also the substance of their teachings. (Author: Trent Angers. ISBN: 0-925417-47-5. Price: $44.95)

Who's Your Mama, Are You Catholic, And Can You Make A Roux? (Book 1)

A 160-page hardcover book containing more than 200 Cajun and Creole recipes, plus old photos and interesting stories about the author's growing up in the Cajun country of south Louisiana. Recipes include *Pain Perdu, Couche Couche*, Chicken *Fricassée*, Stuffed Mirliton, Shrimp Stew, *Grillades*, Red Beans & Rice, Shrimp Creole, *Bouillabaisse*, Pralines. (Author: Marcelle Bienvenu. ISBN: 0-925417-55-6. Price: $22.95)

TO ORDER, list the books you wish to purchase along with the corresponding cost of each. Add $4 per book for shipping & handling. Louisiana residents add 9% tax to the cost of the books. Mail your order and check or credit card authorization (VISA/MC/AmEx) to: Acadian House Publishing, Dept. FSC, P.O. Box 52247, Lafayette, LA 70505. Or call (800) 850-8851. To order online, go to www.acadianhouse.com.